EARLY CELTIC ART

IN BRITAIN AND IRELAND

SHIRE ARCHAEOLOGY

Cover photograph
Red-enamelled bronze horse harness mount
from Santon (Norfolk) or Santon Downham (Suffolk);
height 79 millimetres (3.12 inches).
University Museum of Archaeology and Anthropology, Cambridge.
Photograph: L. P. Morley.

This is for Jonathan
(who has a better eye than either of us)

British Library Cataloguing in Publication Data available.

Published by
SHIRE PUBLICATIONS LTD
Cromwell House, Church Street, Princes Risborough,
Aylesbury, Bucks HP17 9AJ, UK

Series Editor: James Dyer

ISBN 0 85263 679 2

First published 1986

Set in 11 point Times and printed in Great Britain by
C. I. Thomas & Sons (Haverfordwest) Ltd,
Press Buildings, Merlins Bridge, Haverfordwest, Dyfed.

Contents

4

List of illustrations

1
In search of the Celts

Heroic dark-haired poetic peoples, as in revivalist Celtic roman-
ticism, or large fair-haired barbaric drunken touchy savages who
exchanged a slave for a jar of Italian wine and burned criminals
and prisoners alive, as in the accounts of classical authors: we
rarely see the Celts except through the eyes of others since they
had an art which did not hold up a mirror to nature and their own
written history did not begin until, at earliest, the seventh or
eighth centuries AD.

The term 'Celt' covers peoples from Asia Minor to Ireland,
from North Africa to Denmark; it is thus as ambiguous as the art
itself. Despite the claims of present-day partisan groups, the Celts
of the first millennium BC present no more unified an image to
the archaeologist than the Celt of the twentieth century AD does
to the modern political historian.

The name 'Celt' was given by the ancient Greeks to peoples
living in Europe north of the Mediterranean areas and regarded
as barbarians by classical writers. Celts are sometimes defined by
language — Celtic languages still survive as place names in Iberia,
in Scottish and Irish Gaelic (Q-Celtic) and Welsh (P-Celtic, which
is from a later linguistic stock) — and sometimes by their culture
and social organisation. The term is as general in meaning as the
word 'European'.

As a definable culture, the Celts had their origin in late bronze
age Europe of the late second millennium BC. The first major
phase is described as *Hallstatt* and derives its name from the great
Austrian salt-mining complex overlooking the lake of the same
name. This period began possibly around 1200 BC and continued
into the iron age around the middle of the sixth century BC. The
next phase, commencing some time after 500 BC, is named after
La Tène, a Swiss settlement and votive deposit on the shores of
Lake Neuchâtel, and continued until the expanding Roman
Empire swallowed up much of Celtic Europe. During the early
part of this period Celtic peoples, warlike and migratory, spread
over more and more of Europe. In the fourth century they settled
in northern Italy and, according to classical writers, in 390 BC
they sacked Rome; in the following century they pressed down
through the Balkans as far as Asia Minor, sacking Delphi in 279
BC. Celts also settled in Iberia and northern Africa (fig. 1).

By the second century BC, however, expanding Roman might

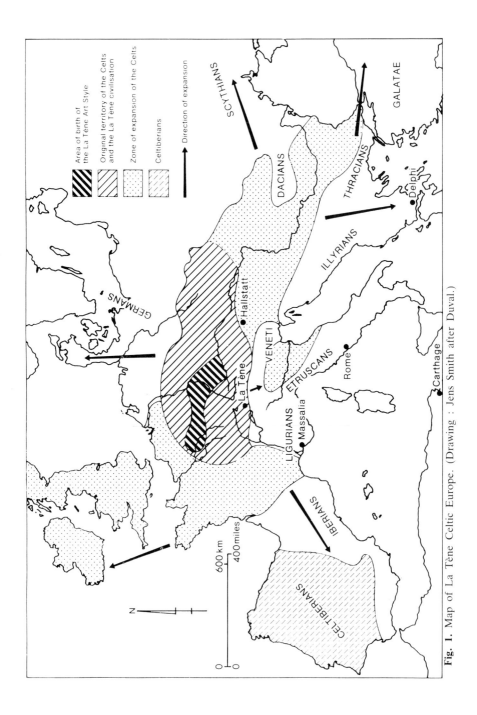

Fig. 1. Map of La Tène Celtic Europe. (Drawing : Jens Smith after Duval.)

was pushing the Celts back. Between 125 and 122 BC Rome conquered southern France, or Provence. Between 58 and 51 BC, Caesar conquered the Celts in Gaul, invading Britain twice in the process, in 55 and 54 BC. Roman occupation pushed on into the Low Countries and southern Germany, the Rhine and Danube forming the military frontier. Britain was permanently occupied from AD 43, though there were constant revolts which Roman punitive might was never fully able to control.

We do not know for certain when 'Celtic' peoples reached the British Isles. They may have been present there from the second millennium BC but although some types of brooches and swords typical of the Hallstatt or earlier iron age phase on the European mainland can be found these are mostly insular developments rather than imports or signs of invasions. Archaeology provides no evidence of major migrations in the British iron age, either for the former idea of an invasion of eastern England from the north-eastern Marne region of France about 350 BC or for a 'Belgic' invasion early in the first century BC. Belgic remains in Britain cannot at present be dated before Caesar's invasions. One theory suggests a 'cumulative Celticity' : a basic British substratum of Celtic peoples, augmented from time to time by small groups of adventurers or invading warriors. The culture of these invaders was basically absorbed into the related culture of the local population; probably there was no major migration of whole peoples into Britain.

Celtic society and Celtic art

Classical writers record the Celts as warlike and courageous, though ill disciplined. During a large part of their history they seem to have been constantly on the move : in the mid first century BC Julius Caesar recorded well over a quarter of a million Helvetii moving out of Switzerland to seek new areas for settlement in France, until forcibly turned back by the Roman army. In the earlier periods, before Celtic expansion, the society seems to have been highly stratified, with a ruling 'princely' group buried in elaborate and richly furnished barrow graves; the later flat cemeteries, whose start overlaps with the latest princely graves, show a wider distribution of material goods but a continuing preoccupation with weapons and horse riding. No evidence for this continental Hallstatt or early La Tène culture has been found in the British Isles.

If we regard 'art' as decoration which goes beyond what is required for simple functional efficiency, we can see that the type

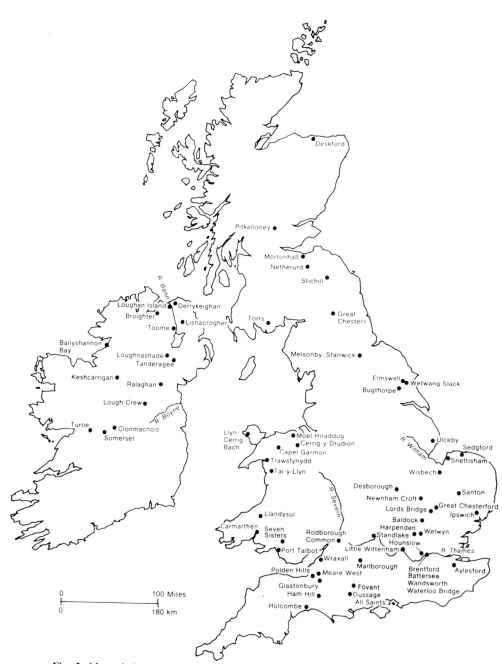

Fig. 2. Map of sites mentioned in the text. (Drawing : Andrew Little.)

and subject matter of that art may well reflect both the social structure and the intellectual and religious preoccupations of the society which created it.

Celtic art tends to fall into two main groups. One is the adornment of weapons of war, horse and chariot fittings, rich personal adornments, and the furnishing of the feast which was a prominent feature of Celtic society. Much of what survives is highly skilled metalwork produced by specialists. In mainland Europe metalworking may, in Hallstatt and early La Tène times, have been attached to major settlements under princely patronage. Later, as in the British Isles, it is not certain whether the metalworkers were settled or whether they were itinerants, producing according to local demand.

The other type of art was produced in connection with Celtic beliefs or religion, of which we have only very fragmentary knowledge. The Druids, recorded by Caesar as the major priestly caste in France and Britain, were historians, judges, astronomers and educators as well as priests; they were the main repositories of the Celtic oral tradition and were regarded by the Romans as a major political threat. Caesar alleges that human sacrifices by burning of criminals or prisoners were presided over by the Druids as part of the Celtic religion. The head appears to have occupied a central role in Celtic iconography, since the head was probably seen as the seat of the soul as well as of the intellect : Celts, like other warlike peoples, took and displayed the heads of fallen enemies as trophies. Certain animals, especially the boar, appear to have played an important part in Celtic beliefs. Religion or ritual seems to have been responsible for the production of much of Celtic stone and woodcarving; there are signs of votive deposits to propitiate various Celtic deities or ask favours from them, often found in lakes, streams, wells or even shafts. Since the beliefs were more widespread in Celtic society than the warrior caste alone, these objects display a wider variation in skill and do not necessarily seem to have been produced by a specialised group.

Celtic art styles

No wholly satisfactory or universally applicable terminology exists to describe the development of pre-Roman Celtic art, particularly in Britain. The term 'style' has often been applied to material which belongs to separate, though possibly related groups. The groupings proposed earlier by Sir Cyril Fox or the enticingly simple numerical system of J. M. De Navarro tend to

oversimplify matters and will not be followed here. The terminology developed by Paul Jacobsthal in his seminal *Early Celtic Art*, published in 1944, is still generally used on the European mainland, though with some modifications. These include:

Hallstatt: largely, though not exclusively, geometric and non-representational, from about 750 BC.

Early (La Tène) style : the legacy of Hallstatt; classical, floral and geometric non-continuous patterns often using compass layout, from about 500 BC (= De Navarro style I) (fig. 3 : 1-2).

Waldalgesheim or vegetal : continuous tendril patterns, from about 325 BC and in part overlapping with the Early style (= De Navarro style II) (fig. 3 : 3-4).

Sword style : from about 250 BC; a sub-style of Waldalgesheim with regional 'schools' centred in Switzerland and Hungary (= De Navarro style III) (fig. 3 : 5).

'Plastic' or three-dimensional, overlapping with Sword style (= De Navarro style III) (fig. 3 : 6).

The art of the oppida period : from about 100 BC to the triumph of Roman provincial art.

De Navarro, followed by Ian Stead, described Celtic art in the British Isles before about 200 BC as style IV, to which Stead has added that of the first centuries BC and AD as style V.

La Tène Celtic art drew much inspiration from the art of Greece and Italy imported by trade or gift exchange, but it remained generally non-naturalistic, accepting only those elements of Etruscan or Greek art which fitted Celtic artistic syntax and predilections. It is a non-narrative art, sometimes dismissed as 'decorative', a label which reflects a restricted modern view of art rather than that of the Celts, who did not accept a separate category of 'art' or artist divorced from other aspects of life. Celtic art is shape-changing and ambiguous, showing elusive, Cheshire-cat images of humans and beasts, images which correspond to the 'shape-changing' of the later Irish hero tales or the recorded Celtic tendency to talk in riddles. However ambiguous, Celtic art is one of the few certain, if obscured, windows on the Celtic spirit.

Sources

There are three main types of sources of information on the Celts in the British Isles. Classical authors such as Julius Caesar and Tacitus have left some accounts. These are always the view of outsiders, sometimes second-hand and always coloured by the authors' interests and preconceptions. Secondly we have very

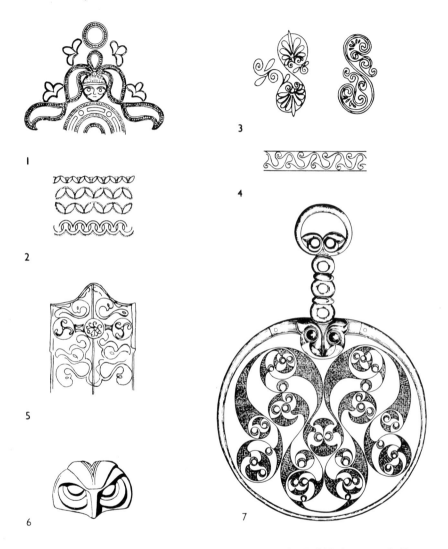

Fig. 3. A first vocabulary of early Celtic art. 1. 'Early' style. Weiskirchen grave I, Germany : detail of gold-leaf covered iron plaque. 2. 'Early' style. Chlum, Czechoslovakia : detail of bronze fitting. 3. 'Waldalgesheim' or 'vegetal' style. *(Left)* The classical source : detail of acanthus motif on Greek red-figure pot. *(Right)* Schosshalde, Switzerland : detail of silver brooch. 4. Developed 'vegetal' style. Sanzeno, north Italy : detail of bronze scabbard. 5. 'Swiss sword' style. La Tène, Switzerland : detail of iron scabbard. 6. 'Plastic', 'Disney' or 'three-dimensional' style. Braa, Denmark: bronze cauldron mount. 7. Insular 'mirror' style. Holcombe, Devon: reverse of bronze mirror. Various scales. (Drawings: A. S. M. Bartlett.)

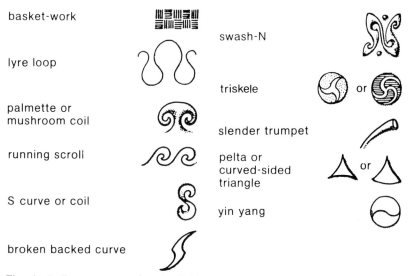

basket-work

swash-N

lyre loop

triskele or

palmette or
mushroom coil

slender trumpet

running scroll

pelta or
curved-sided or
triangle

S curve or coil

yin yang

broken backed curve

Fig. 4. A first grammar of early Celtic ornament. (Drawing : Jens Smith, after MacGregor.)

much later Irish and Welsh literature, committed to writing in the early Christian period from the seventh century onwards under the influence of the church and to be used only with the greatest circumspection in interpreting Celtic societies elsewhere up to a thousand years earlier. Thirdly there is the archaeological record of material remains. On the continent of Europe the broad outline of the archaeological record is quite well established, because of associations with datable classical imports and the increasing use of tree-ring dating, which gives very precise dates, unlike radiocarbon dating. In Britain, however, few finds come from datable contexts, in cemeteries or settlements; many are stray finds found in water with no associated goods, or from metalworkers' scrap or panic burial hoards containing objects from various periods. Some material was found in early unscientific excavation and lacks proper documentation. The British material is thus extremely difficult to date, until very close to the Roman occupation. Some attempt will be made but no certainty applies to it. Local Celtic coins, which developed from Hellenistic Greek and later from Roman prototypes, first appear in Britain around the middle of the first century BC. They require a study of their own and will not be discussed here, although they are much more closely related to other types of Celtic art than some archaeologists are willing to acknowledge.

2
The earliest Celtic art in Britain

It is now generally accepted that Celtic art made no major appearance in Britain until the third century BC and derived, when it did appear, from the Sword style of mainland Europe. The 'dragon-pair' shown on a sword scabbard (plate 1) from the river Thames is characteristic of Celtic swords found across Europe and marks it as an early third-century import. It was certainly the Sword style rather than the earlier vegetal style which supplied the inspiration of insular Celtic art, thus setting it some time after the absolute tree-ring dates of 230 BC on the continent. Britain, however, shows few imports to help us determine where the first Celtic artists in Britain came from. The Cerrig-y-Drudion 'hanging bowl' from Clwyd (plate 2) may be one such import, however, with its vegetal-style tendril design.

The Clonmacnois (County Offaly) torc (plate 3) is, on the other hand, one of the few definite imports discovered in Britain and Ireland. Torcs or neckrings are known to have characterised the continental Celts and classical authors record warriors going into battle naked except for their torcs and their weapons. Sometimes figures of gods can be seen wearing them. This type of torc, with hollow gold tubes, a tenon fastener and buffer ends fused, has its closest parallels in torcs of the Middle Rhine region, which share similar 'vegetal' designs such as the elongated S visible on the torc terminals and the spirals enclosing bosses: the curved meander design on the 'box' at the back is also vegetal or Waldalgesheim in style. We cannot know how this early third-century BC torc reached Ireland. It was found in a bog with a gold 'ribbon' torc of a type previously, but perhaps incorrectly, thought to be late bronze age; from the metallurgical analysis the ribbon torcs have more in common with gold objects of the La Tène period. Whether dowry, gift exchange or trade brought it to Irish shores is a matter for speculation.

Objects of warlike intent characterise the earliest definable British and Irish locally produced art, the so-called Torrs-Witham-Wandsworth group and a number of engraved scabbards from Northern Ireland. There is a handful of putative immediate insular ancestors; one is the bronze scabbard mount from the river Thames at Standlake (Oxfordshire, plate 4). It shows a characteristic vegetal looped shape derived by the Celts from classical prototypes of the lyre, but ending below in a pelta or

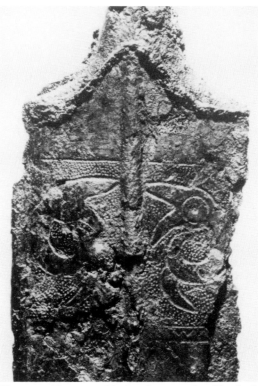

Plate 1. River Thames at Hammersmith, London: sword scabbard with 'dragon-pair': width 51 millimetres (2 inches). (British Museum, London. Photograph: courtesy of the Trustees of the British Museum.)

Plate 2. Cerrig-y-Drudion, Clwyd: fragmentary bronze 'hanging bowl' or lid(s): diameter 250 millimetres (9.8 inches). (National Museum of Wales, Cardiff. Photograph: National Museum of Wales.)

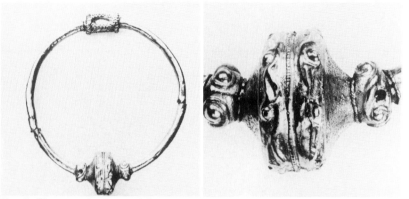

Plate 3. Clonmacnois, County Offaly, Ireland: gold torc, internal diameter 130 millimetres (5.2 inches), diameter of terminals *(right)* 38 millimetres (1.5 inches). (National Museum of Ireland, Dublin. Photograph: National Museum of Ireland.)

curved-sided triangle and set against a background of hatched basketry work. Although basketry is known on the continent, it was there employed as foreground, on the decorative elements, and not as background to vegetal shapes. The Wisbech engraved scabbard (plate 5) also has close ancestors for its stacked lyre-palmette elements in the continental vegetal style, but its symmetry shows that it was locally made.

The scabbard mount from the river Witham in Lincolnshire (plate 6) shows a conscious asymmetry like that of continental Sword Style scabbards. Here the design has first been beaten up from below (repoussé) and later engraved. The repoussé ornament forms a bird, with beak at the lowest point, body and perhaps outstretched wing. The engraving follows the bird's shape closely : there is a palmette on the comma closest to the top. A similar combination of repoussé work, engraving and bird shapes within the tendril design can be seen on the round shield boss from the river Thames at Wandsworth (plate 7). Here there is a 'fold-over' diagonal symmetry. The two predatory birds' heads swirl leftwards into a reversed S curve and to the right they lead into a palmette shape; both end in a leaf spiral. These can be read as two wings. On one palmette-wing is a further incised bird shape and yet another is found engraved once more on the central boss. The eyes of the largest birds still have the pin intended to hold coral studs, as the central raised boss presumably did also.

A longer shield boss was also found in the Thames at Wandsworth. Here again repoussé work in bronze is combined with engraved decoration. The central boss once more shows two

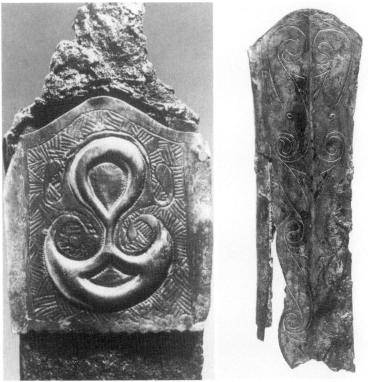

Plate 4. River Thames at Standlake, Oxfordshire: bronze sword scabbard mount, upper plate: width 50 millimetres (2 inches). (Ashmolean Museum, Oxford. Photograph: Univers des Formes.)

Plate 5. Wisbech, Cambridgeshire: bronze sword scabbard: width about 40 millimetres (1.6 inches). (Wisbech and Fenland Museum. Photograph: courtesy of the Trustees of the British Museum.)

birds' heads, symmetrical on a diagonal axis. The surviving end shows a distinctly malevolent grotesque head : barely visible in a photograph but clear in the engraving by Orlando Jewitt first published in 1863 are three hairspring spirals engraved on the nose and a row of tiny curved-sided triangles representing teeth in the mouth : the ducks' bills also contain such incised 'teeth'.

Two complete bronze covers from shields, probably of wood or leather, came from the Thames at Battersea (possibly of later date than the others) (plate 9) and the river Witham (plate 8). Both show signs of considerable remodelling in antiquity. A boar, emblem of ferocity, originally decorated the Witham shield before its remaking; the high-domed coral-inlaid central boss was

then created to allow room behind for a hand grip. The flatter repoussé end roundels show pseudo birds' heads and are supported by 'horse' heads with wing-like ears. There is again engraving on the end roundels, on the horse heads and on the central spine; on the roundels this engraving is a series of S shapes ending in spirals.

Coral was probably obtained from the Mediterranean for the

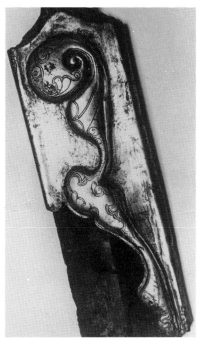

Plate 6. River Witham, Lincolnshire: bronze sword scabbard mount: length 130 millimetres (5.2 inches). (Collection of the Duke of Northumberland, Alnwick Castle. Photograph: Kenneth Graham, Alnwick.)

Plate 7. River Thames at Wandsworth, London: detail of bronze round shield boss: diameter 330 millimetres (13 inches). (British Museum, London. Photograph: R. E. H. Reid.)

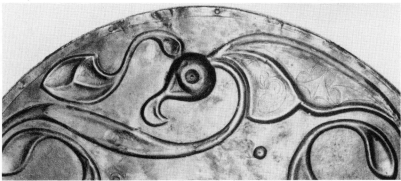

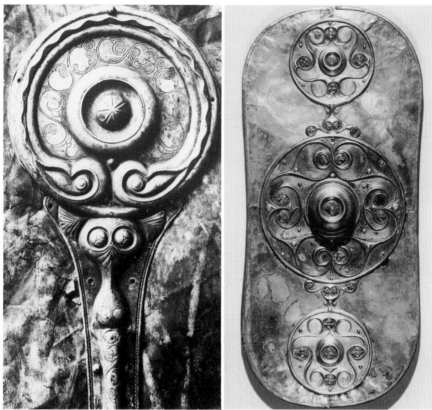

Early Celtic Art

Plate 8. River Witham, Lincolnshire: bronze shield cover with coral inlay : detail showing end roundel with repoussé and engraved decoration : diameter of roundel 140 millimetres (5.5 inches). (British Museum, London. Photograph: courtesy of the Trustees of the British Museum.)

Plate 9. River Thames at Battersea, London: bronze shield cover with red glass inlay: length 775 millimetres (30.5 inches). (British Museum, London. Photograph: courtesy of the Trustees of the British Museum.)

inlay of the Witham shield. It was common on continental material from the fifth to the third centuries BC but seems to have survived slightly longer in Britain. Enamel (or more strictly glass, since it was not fused to the metal until the late first century BC) appears on the Battersea shield. On the continent of Europe such red glass was used in the western Celtic zone mostly in the fourth century BC. In Britain, however, it became a prominent feature of Celtic metalwork of the first centuries BC and AD. True enamelling in several colours continued in Britain during the Roman and post-Roman periods and influenced the emerg-

ence of gospel illumination in Ireland and Britain. Because of this and because the technique used to attach the enamel first to the swastika-type bronze pins and then to the shield by further pins is shared by Roman-period burial finds, some writers have suggested a late date for the Battersea shield. On the contrary, its general three-zone layout, low-relief S-curved repoussé work, the pseudo faces discernible on the central roundels and the two-way monster heads have been used to suggest a much earlier date — in the fifth or fourth century BC. But it seems more reasonable to place the shield a little later than those from Witham and Wandsworth in the second century BC.

Because these objects were all isolated finds from rivers, without associated objects, they may have been votive deposits, and perhaps parade rather than war items, since none was damaged. The emblems on them may have been to ward off harm or to indicate particular personal associations. Since they are later than the Swiss decorated sword scabbards from the La Tène type

Plate 10. Wetwang Slack, North Humberside: bronze canister, diameter 90 millimetres (3.5 inches). (Photograph: courtesy of the Trustees of the British Museum.)

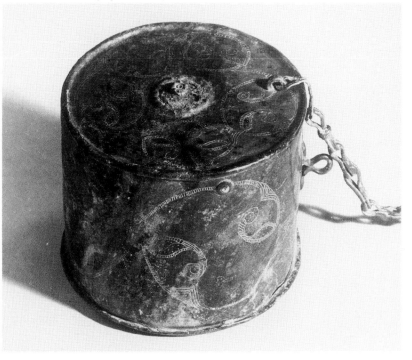

site set by absolute tree-ring dating at 230 BC, and since they are
the product of a mature self-assured style derived from continen-
tal examples but quite different from them in their low-relief
work and their general symmetry, they should not be earlier than
the second century BC. All of these objects seem to come from a
metalworking tradition in eastern England, though whether the
bronze-smiths whose work we see were settled or itinerant is not
clear. Theirs was certainly a warrior, aristocratic art style not
found on more everyday objects: it is possibly connected, as
recent finds indicate, with the Arras or chariot-grave cultures of
eastern Yorkshire and Humberside (plate 10).

 One curious piece of metalwork links this English art style with
that of the earliest Irish pieces. This is the Torrs 'pony cap',
formerly in the private collection of Sir Walter Scott at

Plate 11. Torrs Farm, Dumfries and Galloway: bronze 'pony cap' : length 310 millimetres
(12.2 inches), height at semicircular end 87 millimetres (3.4 inches). (Royal Museum of
Scotland. Photograph: Royal Museum of Scotland.)
Plate 12. Torrs Farm, Dumfries and Galloway: bronze 'pony cap' detail of horn engraving
showing face *(upper right):* height of head 11 millimetres (0.4 inches).(Royal Museum of
Scotland. Photograph: J. V. S. Megaw.)

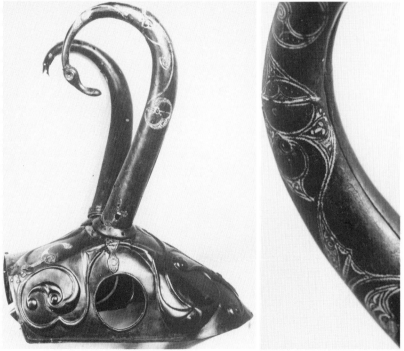

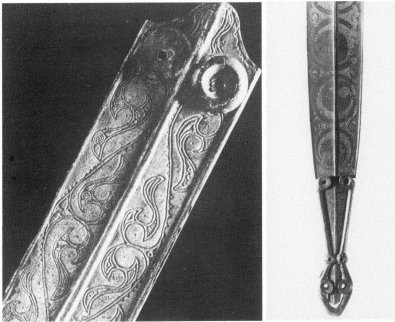

Plate 13. Lisnacrogher, County Antrim, Northern Ireland: details of bronze sword scabbard plates: widths 41 and 46 millimetres (1.6 and 1.8 inches). *(Left.* British Museum, London. Photograph: Belzeaux-Zodiaque. *Right.* Ulster Museum, Belfast. Photograph: Ulster Museum.)

Abbotsford and found in south-west Scotland (plates 11, 12). It was considerably altered in antiquity and carries several repair patches. The birds' heads on the repoussé cap are echoed in further engraving on the horns, which end in cast birds' heads. One horn has a tiny engraved human face on it, next to a break in the design, considered characteristic of the way continental scabbard engravers made a break to allow room for the suspension loop of the sword. But, as with other insular material of this group, the similarities with continental Sword style objects give no more than a hint of an ultimate source of inspiration or origin of insular Celtic art.

The eight Northern Irish bronze scabbards come from in or near the river Bann in Counties Antrim and Londonderry, again with no other objects to help date them (plates 13, 14). Their engraved designs are based upon S curves or stacked C commas; two bear pseudo birds' heads, and the designs are very similar to those of the Torrs horns, and also to the design on the repoussé cap. They carry all-over decoration, unlike their presumed

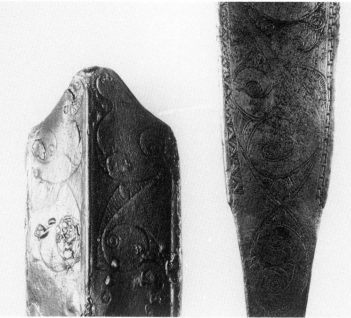

Plate 14. Details of bronze sword scabbard plates. *(Left)* Fovant, Wiltshire: width 45 millimetres (1.8 inches). (Salisbury and South Wiltshire Museum.) *(Right)* River Bann at Toome, County Antrim, Northern Ireland: width 39 millimetres (1.5 inches). (British Museum, London.) (Photograph: courtesy of the Trustees of the British Museum.)

continental predecessors, and their extensive use of hatching marks them as a new development in Celtic art. Though one sword has some continental features, it also has decorative parallels to a sword from Fovant in Wiltshire (plate 14); others are more closely similar to the incised patterns on two sword scabbards and a curious bronze canister found in chariot burials at Wetwang Slack in Humberside (plate 10) and connections with Humberside or a common origin for the Irish scabbards and the English metalwork school would seem likely even without the evidence of the Torrs pony cap.

These scabbards seem to have been made by a number of different hands of varying degrees of skill and over a period of time. They come from the area of the earliest definite Celtic settlement in Ireland, and a date in the early second century BC is again likely.

Connections between Ireland and Wales in the second century have been suggested on the evidence of a disc from a horn mouth found in Loughnashade, County Antrim (plate 15). This is similar

to another found in a votive deposit in a former lake at Llyn Cerrig Bach on the island of Anglesey. However, the Loughnashade disc, with its ubiquitous birds' heads, has its closest parallels in the designs on the Torrs pony cap and on the Battersea shield, so its origins may be British not Irish and its date slightly later in the second century BC.

Standing at the end of this formative period in Celtic art is the so-called Brentford 'horn-cap'. This object may possibly have been part of a chariot yoke, like some other plainer examples from the south of England (plate 16). It used to be considered as an early import of the late fourth-century vegetal style. It is now better interpreted as a later British development, since its trumpet scrolls are not continuous, showing a later style, and its careful symmetry is typical of British rather than continental art.

Plate 15. Loughnashade, County Antrim, Northern Ireland: bronze disc from mouth of horn: diameter 203 millimetres (8 inches). (National Museum of Ireland, Dublin. Photograph: National Museum of Ireland.)

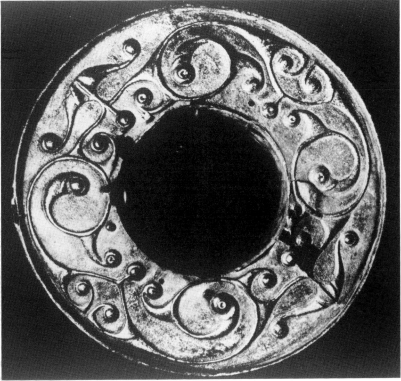

Its extensive use of red 'enamel', now mostly lost, also suggests a date in the first century BC. Like the hinged armring from a chariot burial at Newnham Croft in Cambridgeshire, also once considered as an import, the Brentford chariot piece is probably relatively late in the evolution of Celtic art in the British Isles.

Of enormous importance to the development of this art is the crescentic bronze plaque, possibly from a chariot, found in the Llyn Cerrig Bach deposit near the Druidic centre of Mona (ancient Anglesey) (plate 17). This shows the bird's head motif so evident in the Torrs-Witham-Northern Ireland metalwork. It is, however, formed into a not quite symmetrical triple whirligig or triskele, a motif widely found in later British and Irish art. Also significant is the importance given to the voids, or blank areas, as well as to the relief design. The interplay between foreground and background is typical of the illusionist game which makes Celtic art change shape and meaning like Celtic deities. The bell-shaped peltas (or curved sided triangles) appear as elements in their own

Plate 16. River Thames at Brentford, London: bronze (?) chariot fitting with traces of red 'enamel': height 62 millimetres (2.4 inches), diameter about 80 millimetres (3.1 inches). (Museum of London. Photograph: Museum of London.)

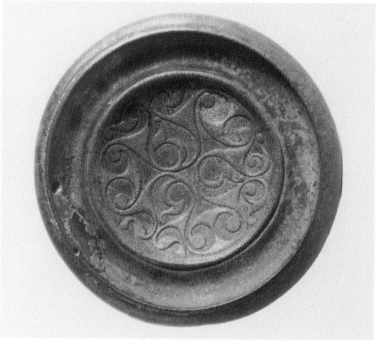

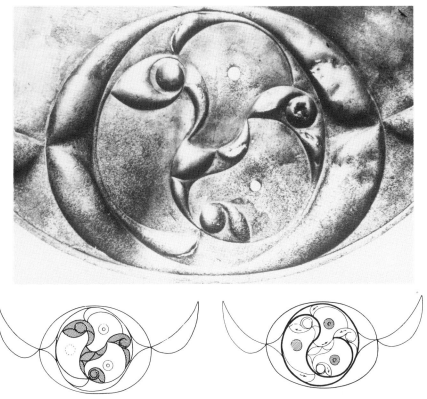

Plate 17. Llyn Cerrig Bach, Anglesey, Gwynedd: detail of bronze (?) chariot fitting: maximum diameter of decorated area 67 millimetres (2.6 inches). (National Museum of Wales, Cardiff. Photograph: National Museum of Wales; drawings after Duval.)

right again and again in mature British and Irish art such as the mirrors (plates 18-20) or the gold work (plates 23-24). The enclosing three trumpet shapes within the outer rim are another long-lasting feature in the art of the British Isles, surviving in Ireland in elegant and elongated form possibly as late as the sixth century AD.

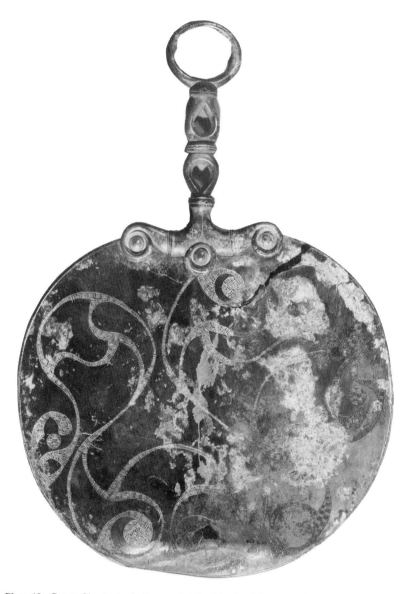

Plate 18. Great Chesterford, Essex: detail of back of bronze mirror: total height 235 millimetres (9.3 inches). (University Museum of Archaeology and Anthropology, Cambridge. Photograph: University Museum of Archaeology and Anthropology.)

3
Later Celtic art

In the first century BC and the first century AD, when Celtic power on the European mainland was in decline, the art of Britain and Ireland became more widespread and even more innovative. Britain also entered a period of close contacts with Europe after a period of relative isolation and regionalisation between the fourth and first centuries BC. Economic contacts with the Mediterranean are evidenced by the importation of wine and oil amphorae and of luxury metalwork from Italy. In the central southern part of Britain, where many of the English late iron age hillforts are situated, trade concentrated on the port serving Hengistbury Head (Dorset): it appears to have come via the Armorican peninsula until Caesar destroyed the fleet of the Armorican Veneti in 56 BC. Further east, in areas of England which contained no hillforts, trade patterns developed from the mid first century BC and were centred on Essex and the Thames valley. This more easterly trade reflects the military demand for foodstuffs as a result of the Roman army's push into northern Gaul and southern Germany. The connections with the continent are also shown by the presence of Gallo-Belgic coins, which were probably continental Celtic payments for the services of British mercenaries against Julius Caesar. Caesar claimed British support for his Gallic adversaries as the reason for his invasions of Kent in 55 and 54 BC and said that the Belgae, a tribal group centred on the Maas and the Lower Rhine, had invaded Britain a short time earlier. The emergence in south-east Britain, particularly in the Thames valley, of new burial rites and wheel-turned pottery is attributed to the Belgae; the archaeological evidence so far has produced nothing earlier than Caesar's invasions.

Outside southern England there were other culturally distinctive regions such as Wales and Ireland. Northern England and southern Scotland did not, however, become important sources for Celtic art until the middle of the first century AD, when Roman military power had shattered the military and political structures of the southern Celts between the Claudian conquest of AD 43 and the defeat of the Iceni of East Anglia following Boudica's unsuccessful revolt in AD 60-1 together with the near-simultaneous destruction of the Druidic centre of Mona in AD 61 under orders from Agricola, Claudius' military governor of the new province of Britannia.

Mirrors

The series of mirrors found from as far west as Cornwall to East Anglia, with one example from a cemetery attached to a Roman legionary base near Nijmegen in the Netherlands, shows a more peaceful and more feminine aspect of Celtic art. The idea of mirrors seems to have been copied from the Roman world and Roman design may have influenced their layout. There are very few Celtic mirrors of any period from the European mainland. Most of the later insular types bear a three-part engraved design on the reverse. The layout is based on a looped lyre (fig. 4), although some designs are more complex than others. The decorative craftsmanship, especially on some of the eastern mirrors such as that from Great Chesterford (Essex, plate 18), is provincial, in every sense of the word, and poorly executed, though the mirrors themselves are competently made.

With the exception of the earliest, probably pre-Caesarian, iron mirrors from the Arras group of Yorkshire and Humberside barrows, the mirrors are all made of bronze and decorated on the back, most frequently with hatched basketwork. In the light, the interplay of matted and smooth surfaces produces a constantly changing impression. On these pieces we can see one of the prime characteristics of mature insular art, that is the importance given to the blank areas enclosed by the hatched decoration, as well as to the worked areas themselves. On the Desborough (Northamptonshire) mirror for example (plate 19) the hatched curved-sided triangular shapes, which, linked, form much of the enclosing design, are echoed in the larger smooth areas enclosed; similarly enclosed are comma shapes with eared ends, which echo those in which the lyre shape ends at left and right of the mirror. The design has been very carefully conceived, and it was executed with the aid of compasses : compass design is a feature of much mature insular art. Many of the mirrors were found in women's graves which can be definitely dated to the last few decades BC and to the first half of the first century AD.

Reversal of shapes between hatched and plain areas can be seen again on the closely related and equally accomplished Holcombe mirror from Devon (figure 3:7). Here again curved-side triangles are present in the three-part design. These mirrors were intended to be hung upside down on the wall until needed; only in this position can one see such features as the cat or owl face where the handle joins the mirror plate on the Holcombe mirror. This shape of the face is also repeated in the design of the mirror itself; a similar 'face' can be seen in an enamelled harness

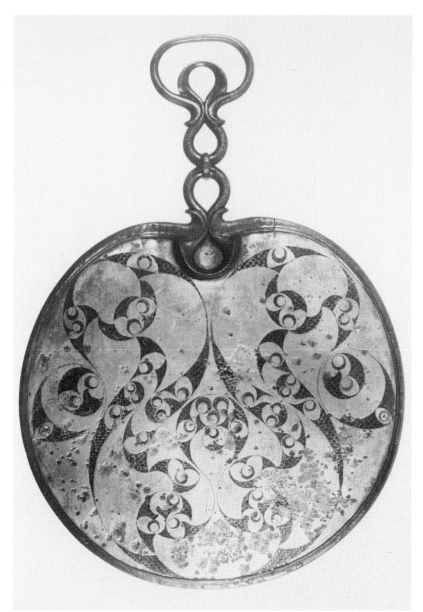

Plate 19. Desborough, Northamptonshire: decorated back of bronze mirror: height 350 millimetres (13.8 inches). (British Museum, London. Photograph: courtesy of the Trustees of the British Museum.)

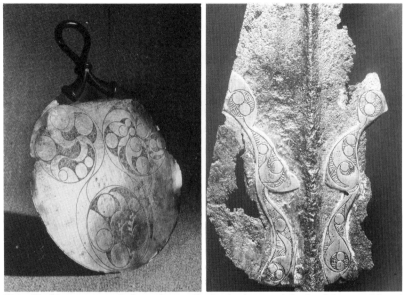

Plate 20. Unprovenanced: ? south-east England: decorated back of bronze 'Mayer' mirror: height 225 millimetres (8.9 inches). (Merseyside County Museums. Photograph: Merseyside County Museums.)
Plate 21. River Thames: Iron spearhead with decorated bronze plates: length of ornament 90 millimetres (3.5 inches). (British Museum, London. Photograph: J. V. S. Megaw.)

mount from the Polden Hills in Somerset (plate 26).

The unprovenanced 'Mayer' mirror, possibly one of the earliest, shows a simpler version of the lyre, a design executed with consummately economical craftsmanship (plate 20). The patterns contained within each of the three roundels are quite different, asymmetrical internally and lacking the reflection of shape between hatched and plain areas. This assured asymmetry is very different from the layout of the other two mirrors shown here, but whether one can detect regional 'schools' or just different craftsmen is uncertain.

Similar basketry to that of the Mayer mirror can be seen on the four decorated bronze plates attached to the head of an iron spear found, like so many fine pieces of Celtic weaponry, in the river Thames (plate 21). The 'mirror style' also appears in the decoration of a sword from Bugthorpe in North Humberside (plate 22), showing clearly that the design elements and techniques were not confined to the mirrors.

Richly decorated scabbards continue to be found in this period

also. One unusual one which combines a number of stylistic features was found near a hillfort at Little Wittenham in Oxfordshire (plate 22). The three-dimensional treatment of the chape (the reinforced tip of the scabbard) recalls the mirror handles : the incised laddering (found on one earlier scabbard in Britain from the river Trent) is found in the Sword Style of Switzerland, especially at the type site of La Tène. The repoussé ornament at the top is rare for British scabbards and contains curved-triangle voids like those on the Llyn Cerrig Bach plaque (plate 17). The shape of the lyre design recalls that of many of the mirrors, especially the Mayer mirror. Some features of the layout

Plate 22. *(Left)* Little Wittenham, Oxfordshire: bronze sword scabbard, detail of top: width 63 millimetres (2.5 inches). (Ashmolean Museum, Oxford. Photograph: Ashmolean Museum.) *(Right)* Bugthorpe, Humberside: bronze and iron sword scabbard: width 45 millimetres (1.8 inches). (British Museum, London. Photograph: courtesy of the Trustees of the British Museum.)

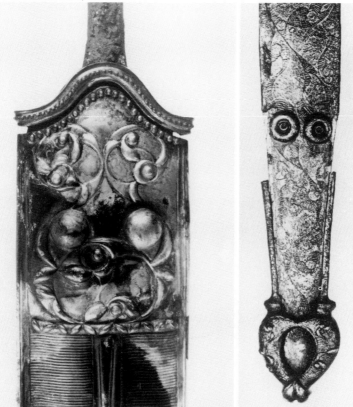

of the design are similar to features of the Snettisham torc dealt with below (plate 23).

Gold ornaments and the Snettisham-Ipswich style

Among the most spectacular of English iron age finds are the hoards of torcs and armrings found mainly in East Anglia, in the territory of the Iceni. The torc illustrated in plate 23 is electrum (an alloy of gold and silver) rather than pure gold. It was found in 1950 during ploughing at a depth of between 7 and 12 inches (180 to 305 mm) below the surface at Ken Hill near Snettisham, in Norfolk; one earlier find of tubular gold torcs had been taken for part of a brass bedstead and at first left lying by a main road. Some five separate hoards were found including coins, ingots and scrap material of bronze, tin and gold, together with some signs of metalworking, but it is not clear whether this was a metalworker's stock in trade buried in time of danger or, as in several continental cases including neckrings with coins, a votive or ritual burying of these objects.

Dio Cassius records that Boudica, the queen of the Iceni who led her people in their doomed revolt against the Romans, customarily wore a great golden neckring, and the Snettisham torc is spectacular enough for a queen, but it is probably slightly too early to have been Boudica's.

The Snettisham hoards also contained gold tubular torcs of a type mainly known from the European mainland, as well as a

Plate 23. Snettisham, Norfolk: electrum torc from Hoard E: diameter 200 millimetres (7.9 inches). (British Museum, London. Photograph: Univers des Formes.)

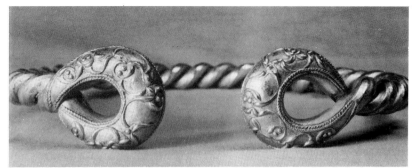

Plate 24. Ipswich, Suffolk: gold torc: diameter 187 millimetres (7.4 inches). (British Museum, London. Photograph: courtesy of the Trustees of the British Museum.)

large number of local British coins. The splendid gold torc cannot have been made before about 50 BC since one of its separately cast terminals contains a well worn Gallo-Belgic coin dating from around 58 BC. Though some items in the hoards were obviously older, this torc and the accompanying bracelet are apparently from the same hand and made shortly before the time of burial, probably in the latter half of the first century BC or the first decades AD.

Each of the eight main strands of the torc is itself composed of eight twisted wires, soldered into the terminals. Chased and engraved ornament was added to the terminals after they had been cast. The edges of the ornamented areas are defined by crimped wavy lines or by lines of beading. The slender cast ridges enclose areas of matting. Within the matting are concentric circles and much smaller cast dots with three tiny punch marks on them. These are characteristic trademarks of the Snettisham style: the plain areas are of less importance to the overall design than on the two-dimensional mirrors.

Other examples of this style can be seen in a very similar gold torc terminal found at Netherurd in Peeblesshire (Borders), also with coins of a similar date, and another from Sedgeford in Norfolk.

The style may also be seen on a hoard probably representing another metalsmith's stock in trade from Belstead near Ipswich, unearthed during building operations in 1968, and containing six twisted, faceted gold torcs with loop terminals (plate 24). These are apparently unfinished: the engraved ornament added after casting to the Netherurd, Sedgeford and Snettisham terminals is not present, though the general layout of slender trumpet ridges

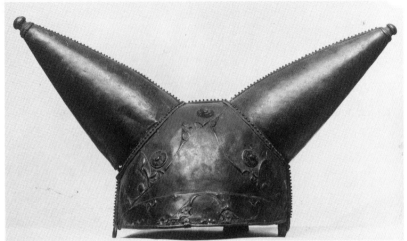

Plate 25. River Thames at Waterloo Bridge, London: bronze horned helmet with red 'enamel' inlay: height of cap 160 millimetres (6.3 inches), width between horns 425 millimetres (16.7 inches). (British Museum, London. Photograph: J. V. S. Megaw.)

defining curved-sided triangles and the provision of tiny dots are very similar, but the dots lack the punch marks.

Versions of this ornament can also be found on objects such as the horned bronze helmet from the river Thames at Waterloo (plate 25) and the fragmentary horse bit from Ulceby in Lincolnshire. The helmet is very thin and rather small, so it may have been an object of display, a parade item rather than a real war helmet. The stringiness of the design and the much greater area over which it is spread tend, at first glance, to disguise its similarity to the Snettisham torc : but the matting in curved-sided triangles, the long slender sinuous ridges and the tiny knobs with three punch marks are very like the more concentrated decoration on the Snettisham torc and bracelet.

Welsh and Irish origins or connections have been claimed for this style. In one case this is based on some decorative elements in a parcel gilt brooch from Carmarthen (plate 57), of a type mostly found within the Roman provincial area, both in Britain and mainland Europe; similarities are claimed also with the gold torc from Broighter in Ireland (plate 45), but this bears only superficial resemblances to the Snettisham style (plates 23-24). In view of the concentration of the findspots of most of this material in East Anglia and adjacent regions, it makes more sense to see that as the centre of the style with outlying objects arriving in Scotland or Wales by means of trade or with their owners or

makers, whether refugees or otherwise.

That the style of gold torcs should be found also on bronze and iron objects is not surprising : metalworkers appear to have worked in a variety of metals and the Snettisham 'scrap' itself contained bronze and tin as well as gold.

Horses and their equipment

Evidence for widespread use of horses and the production of horse and vehicle fittings in the Celtic world is also found in Britain. A large defended settlement at Gussage All Saints in Dorset has produced, however, some of the very rare evidence for this work in progress, rather than just as finished products. Here were found several thousand fragments of the fragile clay moulds, individually made round wax models, in which the bronze and iron pieces for at least fifty matched sets of horse harness and chariot equipment were subsequently cast by the lost wax or *cire perdue* method. The high degree of technical skill and decorative ability shown in these moulds compares well not only with medieval metalworking but with methods used until the nineteenth century; the quantity of material found also implies that British Celts were able to field a considerable number of horses, chariots and warriors in an emergency, since this workshop served only a small area over a relatively short period of time. Many of the types of three-ring horse bits, terrets (rein rings on chariots), chariot linchpins and the like are found in the archaeological material, particularly from southern England,

Plate 26. Polden Hills, Somerset: enamelled bronze harness mount: width 151 millimetres (5.9 inches). (British Museum, London. Photograph: Univers des Formes.)

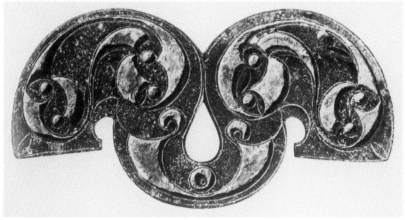

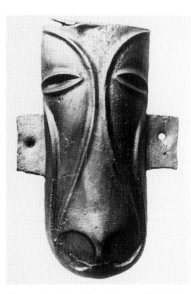

Plate 27. Melsonby, near Stanwick, North Yorkshire: bronze (?) chariot mount with horse face: height 109 millimetres (4.3 inches). (British Museum, London. Photograph: courtesy of the Trustees of the British Museum.)

though also further afield including East Anglia. Radiocarbon dating, together with associated finds, put Gussage All Saints in the first century BC, well before this area had to face the onslaught of the Roman legions. The specialisation in horse and chariot fittings indicates belligerent rather than peaceful intent, implying that inter-tribal local hostilities were frequent. Unfortunately, the evidence does not allow us to say whether the metalsmiths who produced all this material were resident workers or whether they were itinerant craftsmen who moved from area to area as their fancy or market demand led them.

Among the more spectacular examples is the red-enamelled harness mount from a nineteenth-century find at Santon, Norfolk (or possibly Santon Downham, Suffolk) (cover illustration). Its four-lobed structure is created from two flattened lyres joined together. The eared comma shapes at each corner form yin-yang motifs and contain pseudo birds' heads, echoed elsewhere within the design. The enamelled sections form curved-sided triangles. Similar mounts have been found in the area of the Polden Hills in Somerset (plate 26), Norton and Westhall in Suffolk and in London. Another has been found in northern France and this, like the London mount, adds yellow enamel and that from Westhall red, green, blue and white inlay. Typical Cheshire-cat faces can be seen in these mounts, with horns or scrolled headdresses as on the Battersea shield (plate 9).

Typical of the care given even to those objects which would not show is the decoration on an unprovenanced Irish three-link horse bit (plates 28 and 29). This bit shows birds' heads which reverse into human faces; it also carries an extraordinary twisted human face on the bulb of the surviving outer ring, created from four simple lines. Such treatment of representational art by reducing it to its essentials rather than attempting to copy from nature can also be seen in the beautiful little equine mask, possibly a chariot mount, from a large hoard of horse trappings found at Melsonby near Stanwick, capital of the Brigantes in North Yorkshire (plate 27). Here is the very essence of patient horse, distilled, like the Irish face, out of an assured minimum of defining lines. Stanwick was overrun by the Romans in their campaign against the Brigantian leader Venutius between AD 71 and 74; the deposition of the hoard presumably dates from around that time of upheaval and destruction.

Animals and people

In addition to the Cheshire-cat faces of humans and beasts in early Celtic art, there are some three-dimensional representa-

Plate 28. Unprovenanced, Ireland: bronze three-link horse-bit, Surviving length 138 millimetres (5.4 inches). (National Museum of Ireland, Dublin).
Plate 29. Detail of horse-bit, height of face 41 millimetres (1.6 inches). (National Museum of Ireland, Dublin. Photographs: National Museum of Ireland.)

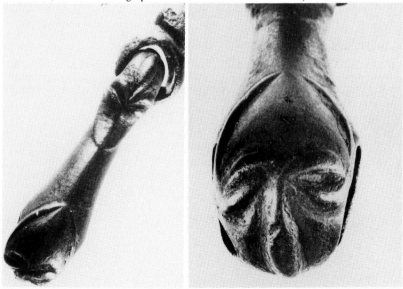

tions. Some decorate buckets or bowls as handle mounts, as do the twin heads on the Aylesford (Kent) wooden bucket, a cremation container from a Belgic burial excavated by Sir Arthur Evans and his father, Sir John Evans (plate 30). The severe face with its almond eyes and lantern jaw and its helmet or headdress has its closest parallels on the European mainland; some of the decorative details such as the ridged edging, however, recall Welsh material of the very late pre-Roman period. Whether gods or humans, these heads, like the bucket they adorn, suggest that its owner had strong cross-channel connections. Other such buckets have been found in Marlborough (Wiltshire) and at The Tene Estate at Baldock (Hertfordshire): the latter burial had two buckets with three surviving human heads as handle mounts, poor but related versions of the Aylesford heads. All the buckets have square tripod feet as do their continental counterparts, and

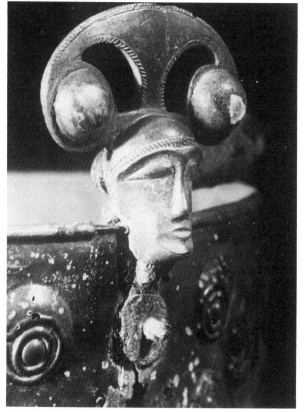

Plate 30. Aylesford, Kent: bronze bucket handle mount in form of a head: height of head 40 millimetres (1.6 inches). (British Museum, London. Photograph: J. V. S. Megaw.)

Plate 31. Welwyn, Hertfordshire: bronze face mounts: height of largest head 38 millimetres (1.5 inches). (British Museum, London. Photograph: J. V. S. Megaw.)

all were found with Roman bronze drinking vessels. Britain at this late period in the first century BC was the northernmost, if beleaguered, outpost of a Celtic empire in retreat before the Romans.

Continental affinities are also very clear in the three tiny moustachioed faces found in another Belgic chieftainly cremation grave, from Welwyn (Hertfordshire, plate 31). By the first century BC Celts were more usually clean-shaven, having abandoned the earlier flowing moustaches; these faces could be deities not men.

The stone or more rarely wooden figures from the British Isles are even harder to date than the metalwork, and of very uncertain purpose; the few putative deities mostly come from the Roman period. The fierce, apparently helmeted figure from Tanderagee in Northern Ireland is reminiscent of continental pillar stones (plate 32). Double or even triple-faced heads are also known while the iconography of such pieces as the much weathered sandstone head from Port Talbot (plate 33) tempts comparison with late Hallstatt or early La Tène iron age carvings of the sixth to fourth centuries BC. It is more likely, however, to be no earlier than the Roman period.

The mournful carved yew figure from Ralaghan (County Cavan, plate 34) has only the most general of resemblances to continental carving such as the small wooden votive figures from Sources-de-la-Seine which are of oak heartwood. The Ralaghan figure, however, reminds us how much art must have been lost in perishable material such as wood or bone. The Irish figure may be female or may have had a penis attached via the hole; the peg shows it was mounted on something. There is no indication of

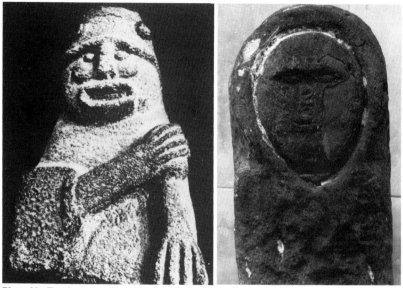

Plate 32. Tanderagee, County Armagh, Northern Ireland: carved stone figure: height about 600 millimetres (24 inches). (Chapter House, Armagh Protestant Cathedral. Photograph: Dr F. Henry.)
Plate 33. Port Talbot, West Glamorgan: sandstone pillar with human face: height 650 millimetres (25.6 inches). (National Museum of Wales, Cardiff. Photograph: J. V. S. Megaw.)

date, however; the figure has analogies in Irish bronze age wood carving but could be as late as the second century AD. It has not been scientifically dated. It is extremely rare in the British Isles in showing a full-length figure rather than just a head.

Given the wide usage of Celtic cultic beasts, it is not surprising that there are a number of animal figures as well. Most common is the boar; one of these, found at Hounslow (Greater London), with its ferocious head lowered and its crest standing high, is the essence of wildness (plate 35). Another boar forms the spout of a bowl found at Lęg Piekarski in Poland (plate 35). The bowl is of a type made mostly in south-west England in the first century BC or the early decades of the first century AD; how it got to Poland is a matter for speculation.

The boar, as a key part of the otherworld feast, frequently accompanied Celtic warriors into the grave, in the form of joints of pork, and was also a symbol of courage in battle. The carnyx or animal-headed war trumpet, seen on Belgic Celtic coins from

south-east England, in a rare example from Deskford in Banffshire (Grampian, plate 36) takes the form of a boar. The damaged head has lost its crest, but the creature has a pig's palate within its mouth and when found in a peat bog in 1816 it had a movable wooden tongue. Stylistically the slender trumpets composing the eyes of this Scottish example are typical of one style of northern British and late Irish metalwork discussed

Plate 34. Ralaghan, County Cavan, Ireland: carved yew figure: height 1.14 metres (45 inches). (National Museum of Ireland, Dublin. Photograph: National Museum of Ireland.)

Plate 35. *(Upper)* Hounslow, London: bronze boar figurine: length 80 millimetres (3.1 inches). (British Museum, London. Photograph: J. V. S. Megaw.) *(Lower)* Łęg Piekarski, Turek, Poland: bronze bowl spout in shape of a boar: length of spout 75 millimetres (3 inches) (Państwowe Muzeum Archeologiczne, Warsaw. Photograph: T. Biniewski, Warsaw.)

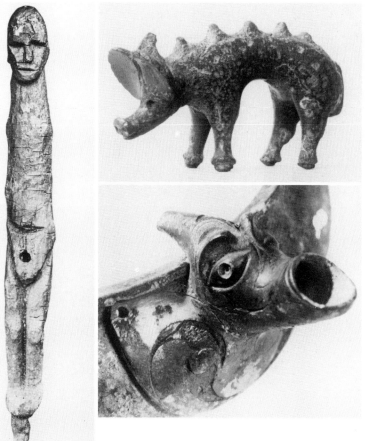

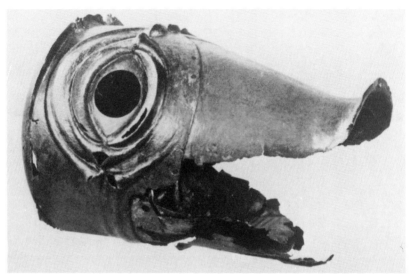

Plate 36. Deskford, Grampian: bronze war trumpet mouth in shape of a boar: length 215 millimetres (8.5 inches). (Royal Museum of Scotland, Edinburgh. Photograph: Royal Museum of Scotland.)
Plate 37. *(Left)* Ham Hill, Somerset: bronze vessel mount in shape of a bull: length 40 millimetres (1.6 inches). (Somerset County Museum, Taunton. Photograph: Somerset County Museum.) *(Right)* Lord's Bridge, Barton, Cambridgeshire: bull-headed terminal of wrought iron Belgic firedog: total height 710 millimetres (28 inches). (University Museum of Archaeology and Anthropology, Cambridge. Photograph: University Museum of Archaeology and Anthropology.)

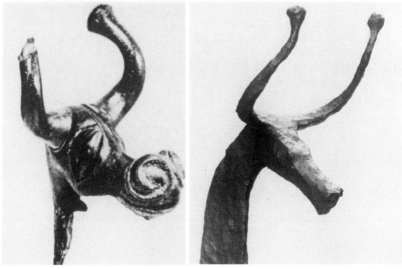

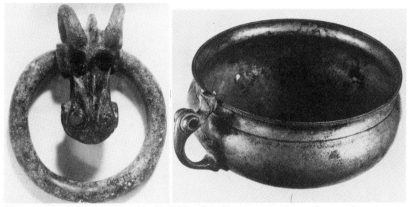

Plate 38. *(Left)* Harpenden, Hertfordshire: handle mount in shape of a ram from bronze bucket: length 75 millimetres (3 inches). (Museum and Art Gallery, Luton. Photograph: Museum and Art Gallery, Luton.) *(Right)* Keshcarrigan, County Leitrim, Ireland: duck-shaped handle for bronze bowl: diameter of bowl 142 millimetres (5.6 inches). (National Museum of Ireland, Dublin. Photograph: National Museum of Ireland.)

below. It is possible that refugees from the Roman onslaughts further south may have made it; one inspired Celtic flight of fancy imagines it sounding against Agricola's legions at the battle of Mons Graupius in AD 84-5, which may have been near Deskford.

Domestic animals such as cattle or sheep can be seen in three dimensions on bucket mounts or as chariot fittings from sites such as Ham Hill (Somerset), Bulbury (Dorset) or Harpenden (Hertfordshire) (plates 37-8). Lively and amiable, these beasts are among the friendliest animals in the Celtic repertoire.

Wrought iron firedogs with ox or bull heads are encountered as part of the funerary feast in several of the 'Belgic' graves in south-eastern England (plate 37, right). The dozen or so continental examples which provide close parallels are not usually found in graves; the later, Welsh-made examples from Capel Garmon in Gwynedd may again suggest some Belgic refugee from Roman might (plate 43).

Unmistakable birds appear too, such as the delightful duck's head on the handle of a bowl found at Keshcarrigan (County Leitrim, plate 38). Like the bowl found in Poland (plate 35), this is of a type made in south-western England, and despite claims that both bowl and handle were made in Ireland it is an import from Britain. The lively little duck has ancestors back in the bronze age or early Hallstatt times and is a charming companion

to the birds' heads and pseudo birds' heads found on so much Celtic metalwork in the British Isles.

When one adds to these the Cheshire-cat faces on the Battersea shield, Holcombe mirror and Polden Hills mounts and the Melsonby mask or the horse heads on the Witham shield (fig. 3: 7; plates 8, 9, 26, 27). it can be clearly seen that Celtic artists were not indifferent to nature nor unable, when they wished, to represent essential characteristics with consummate abstract and abstracting skill.

Plate 39. Tal-y-llyn, Gwynedd: engraved bronze shield mount with triskele motif: diameter 85 millimetres (3.3 inches). (National Museum of Wales, Cardiff. Photograph: National Museum of Wales.)

4
Wales and Ireland

Wales

There are major problems in assessing the evidence for the production of art in Wales. Much of the decorated metalwork comes from hoards such as that at Llyn Cerrig Bach on Anglesey : this is apparently a ritual deposit accumulated over a long period of time and from a wide range of geographical areas. Other hoards, such as those from Seven Sisters (West Glamorgan) or Tal-y-llyn (Gwynedd), appear to be tinkers' scrap metal also spanning a period of time and containing material as late as Roman date. The Roman objects show that the hoards must have been deposited in Roman times, although some items may well be much earlier in date.

Some modern writers have pressed the case for an important Welsh school of decorated metalwork going back to the third century BC, citing continental parallels for such objects as the Llyn Cerrig Bach plaque (plate 17) and the Tal-y-llyn and Moel Hiraddug mounts (plates 39-41).

The three decorated Tal-y-llyn mounts, probably from shields, show a triskele motif executed in basketry hatching (plate 39), another with a repoussé triskele and further engraving and the third bearing originally a pair of clean-shaven human heads (plate 40) surrounded by a loose tendril pattern. The first uses a rocked engraving tool to produce a zigzag line; its pattern strongly recalls the mirrors, and its use of compass design suggests a first-century BC date. Despite the antiquity of the triskele motif, the use of the triskele is no proof of greater age, since it is also one of the most durable patterns in the Celtic repertoire and survives into the early Christian period. The repoussé triskele mount is probably even later since it is of the 'broken-backed' type most often seen after the Roman conquest (fig. 4). The human-head plaque demonstrates further reasons why archaeologists have hesitated to accept early dates for the Tal-y-llyn material. Its alloy is not the usual La Tène copper-tin bronze but contains a large proportion of zinc, so that it is actually brass, not usually found till the Roman period. This has been explained by pointing to the high proportion of zinc occurring naturally in Welsh copper deposits; some metallurgists, however, say that special smelting techniques are necessary with such ores if the zinc is not to be lost in processing. The date of this plaque thus remains in doubt but may

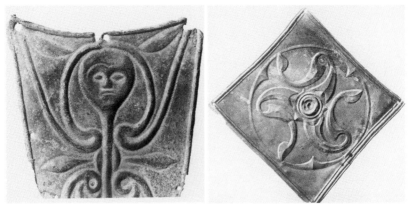

Plate 40. Tal-y-llyn, Gwynedd: engraved zinc alloy, shield mount with human heads: width 104 millimetres (4.1 inches). (National Museum of Wales, Cardiff. Photograph: National Museum of Wales, Cardiff.)
Plate 41. Moel Hiraddug, Clwyd: tin-plated bronze (?) shield mount with broken-backed triskele: length of side 153 millimetres (6 inches). (Formerly Powys Museum, Welshpool, now lost. Photograph: National Museum of Wales, Cardiff.)

well be the late first century AD.

Similar reservations apply to the broken-backed triskele on the Moel Hiraddug plaque, found beneath the collapsed wall surrounding an iron age hillfort (plate 41). Another disputed piece is the brooch from Carmarthen (plate 57). Although there was doubtless a Welsh school of metalwork, and Wales had important connections with the rest of Britain, this was a regional development rather than an early influence on all the art styles of the rest of Britain.

Of generally accepted later date is the surviving half of a collar from the Pen-coed-foel hillfort at Llandysul (plate 42). Its S curves enclose voids like those on the Llyn Cerrig Bach plaque. This collar has a close relative in another from Birdcombe Court, Wraxall (Avon), where the high raised bosses of Llandysul are replaced by settings for glass. The latter is the ancestor of a less distinguished group from south-west England.

In the first century AD there are signs of increasing Belgic influence in Wales, shown by the presence of firedogs such as that from Capel Garmon (plate 43) and by an increase in enamelling of metalwork. It was to Wales that Caractacus, the southern English leader, fled after his defeat by the Romans.

Ireland

Celtic Ireland was never invaded by Romans or Saxons, and despite clear evidence of trading links with Britain and Europe its

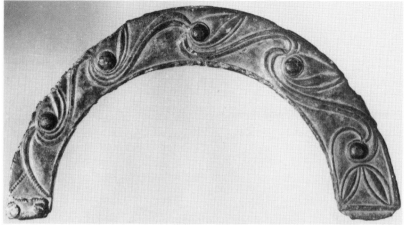

Plate 42. Llandysul, Dyfed: part of bronze neck collar: overall diameter 150 millimetres (5.9 inches). (Bristol City Museum. Photograph: Bristol City Museum and Art Gallery.)
Plate 43. Capel Garmon, Clwyd: wrought iron firedog with ox-head terminals: height of head 250 millimetres (9.8 inches). (Private collection on loan to National Museum of Wales, Cardiff. Photograph: National Museum of Wales.)
Plate 44. Ballyshannon Bay, County Donegal, Ireland: detail of bronze anthropoid sword hilt: height of head about 25 millimetres (1 inch). (National Museum of Ireland, Dublin. Photograph: National Museum of Ireland.)

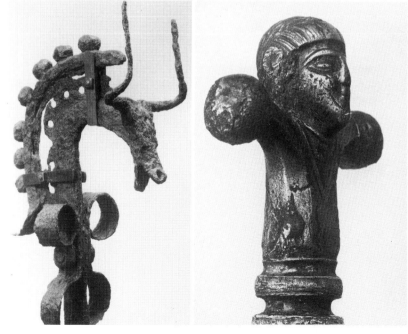

art seems to have evolved in its own fashion. It is even more difficult to date accurately than that in Britain, and Irish writers, especially with later material (plates 50-3), differ by up to five centuries in their dating.

Ireland continues to show a tiny scattering of probable continental imports such as the bronze anthropoid sword hilt from Ballyshannon Bay (County Donegal), which could well have come from southern or south-western Gaul (plate 44). The details of the human head and the type of sword have their closest analogies in late La Tène material of about 100 BC.

Another possible import, but this time locally decorated, is the hollow gold tubular torc with buffer terminals found at Broighter (County Londonderry, plate 45). It was accompanied by other gold objects including a model boat with oars, rowers' benches and a mast, a bowl, two chain necklaces and two undecorated bar torcs, all made from the platinum gold typical of the Irish iron age. The type of the torc and its terminals, with their beaded decoration, is mostly found in north-east France and in Belgium : examples were found among the gold scrap metal at Snettisham in Norfolk. Such torcs are usually not decorated and it has been suggested that the terminals were imported and the torc completed in Ireland. The design has been compared with that of the Snettisham-Ipswich school (above, plates 23-5) but the resemblances are not particularly close. The voids enclosed by the relief design are once again curved-sided triangles like those of Llyn Cerrig Bach, but this is a very common feature in mature

Plate 45. Broighter, County Londonderry, Northern Ireland: gold torc: diameter 195 millimetres (7.7 inches), diameter of tubes 30 millimetres (1.2 inches). (National Museum of Ireland, Dublin. Photograph: National Museum of Ireland.)

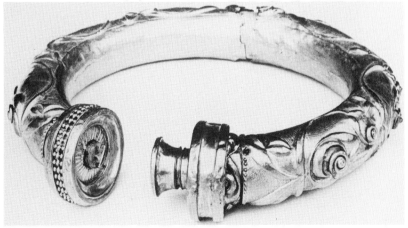

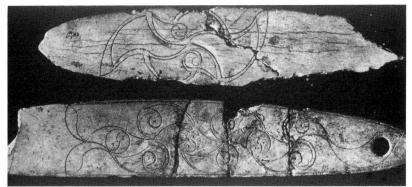

Plate 46. Lough Crew, County Meath, Ireland: decorated bone flakes: length of longest 140 millimetres (5.5 inches). (National Museum of Ireland, Dublin. Photograph: Belzeaux-Zodiaque.)

Celtic art of the British Isles, too common to prove clear relationships. There are also, more significantly, tiny half-moons reminiscent of some found on the Snettisham bracelet. Otherwise the Broighter torc shows a very different style from that of the English rings. The ridges are composed of slender trumpet shapes, which characterise Irish metalwork until the early Christian period; the background, engine-turned matting laid out by compass, is quite different from the hatched basketry background of English mirrors or torcs. The raised spirals on the Broighter torc are unlike the concentric circles of the English torcs, and the wavy outlines are lacking.

The continental buffer-terminalled torcs were mostly deposited around the middle of the first century BC, which would put the Broighter torc between 50 and 1 BC. It has very clear Irish affinities with other pieces such as the Lough Crew bone flakes (plate 46) or the decoration of the Turoe standing stone (plate 48). Several hundred bone flakes and other bone objects (and a compass leg of dubious antiquity) were found in an iron age reoccupation of a megalithic passage grave of the neolithic period. The designs are mostly complex and compass-based: despite suggestions that these were trial pieces for bronze working, no sign of metalworking was found at Lough Crew, although the motifs exhibited on these bone pieces demonstrate an extraordinary anthology of Irish art.

One of the Lough Crew flakes also closely parallels the design on the broken decorated stone from Derrykeighan (County Antrim, plate 47). This stone, like that from Turoe (plate 48), has very definitely Irish designs carved on it. Such stones are not

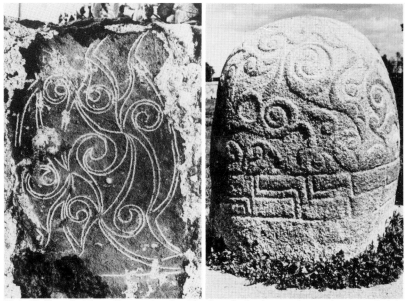

Plate 47. Derrykeighan, County Antrim, Northern Ireland: carved stone fragment: height 905 millimetres (35.6 inches), height of ornamented section 340 millimetres (13.4 inches). (Derrykeighan Old Church. Photograph: Northern Ireland Archaeological Survey.)
Plate 48. Turoe, County Galway, Ireland: carved stone decorated with four panels, view from southwest: height 1.20 metres (47 inches). (Grounds of Turoe House. Photograph: Green Studios, Dublin.)

known elsewhere in the British Isles and only five come from Ireland. Standing carved stones in Brittany have been suggested as the source of the idea of such stones, probably connected with the Irish form of Celtic beliefs, but there is no sign that Breton stone carvers reached Ireland, or any other evidence of a direct connection between Ireland and Brittany. It is, however, possible that Breton influence could have passed to Ireland via south-west England. Incised pottery from the Somerset marsh villages of Meare and Glastonbury (plate 49) shows matting and compass design reminiscent of the Broighter torc and the Lough Crew flakes, and even of the earlier Northern Irish scabbards. Western areas of England were in contact with Brittany through trade.

A number of objects from late iron age Ireland are obscure in function. Among them are the 'Somerset-type' mounts, of which one is illustrated (plate 50). These vary in decoration; this example demonstrates a raised single trumpet coil set against a dotted background and enclosing non-concentric circles, alternatively dotted and plain. Some others are openwork and carry

designs such as triskeles or S curves in the centre. All share the same shape : a very shallow cylinder open at one end and decorated at the other, with fastening rivet holes at the sides; box lids have been suggested. They are named after the hoard from Somerset (County Galway), which produced over half of those known. Such iron age objects are unknown outside Ireland : the other material found at Somerset includes Roman provincial metalwork which dates them to probably the first half of the first century AD.

Long, pencil-slim trumpet curves characterise other Irish bronze objects of unknown use. The Petrie crown (plate 51) was formerly in the private collection of George Petrie, one of the

Plate 49. Meare West and Glastonbury, Somerset: incised pottery vessels : storage jar, height 355 millimetres (14 inches); open bowl, diameter 230 millimetres (9.1 inches); lid, diameter 170 millimetres (6.7 inches). (Somerset County Museum, Taunton. Photograph: A. L. Pacitto.)

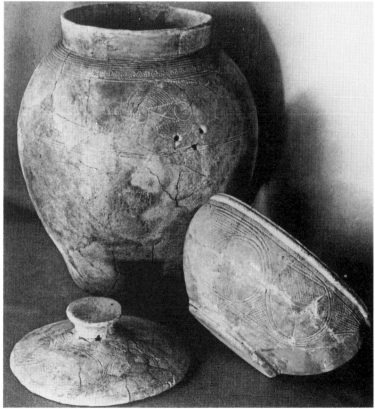

great benefactors of Ireland's National Museum. It consists of two tapering conical horns attached to discs, the whole mounted on a flat strip. The technique seems to have been to pare away the metal surface, leaving the relief decoration standing out. Crested birds' heads are visible on the horn and the frieze; they are also visible on the Bann disc (plate 52), which was made with a similar technique. Birds' heads are extraordinarily persistent in Irish iron age metalwork. The Bann disc is very slightly concave and may perhaps have been a pan from a weighing scale; it still has a wire loop in one of the three edge holes, presumably intended for hanging it up. It has no close parallels; there are, however, three less extensively decorated horns, like those on the Petrie crown, found in Cork. The Petrie crown in its present state must have been too small to wear.

The layout of the 'Monasterevin' disc (one of seven) is similar but not identical to that of the Petrie crown discs; both can also perhaps be read as grotesque faces (plate 53). The technique is, however, different, since repoussé work is used to raise the trumpet curves, which end in snail-shell commas rather than birds' heads; and the background is punched to produce a matt effect. As so often when archaeologists cannot explain the purpose of past objects, ritual or religious use is the best suggestion which can be made.

These objects have been dated anywhere from the first to the sixth century AD, with an earlier date seeming more likely. The slender trumpets are very similar to those seen on the Deskford carnyx (plate 36) and the Melsonby horse mask (plate 27), both probably late in the first century : and the cross-in-circle motif on

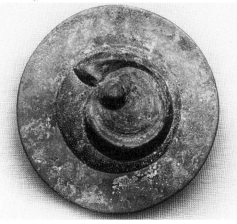

Plate 50. Somerset, County Galway, Ireland: bronze (?) box lid: diameter 81 millimetres (3.2 inches), height 13 millimetres (0.5 inches). (National Museum of Ireland, Dublin. Photograph: National Museum of Ireland.)

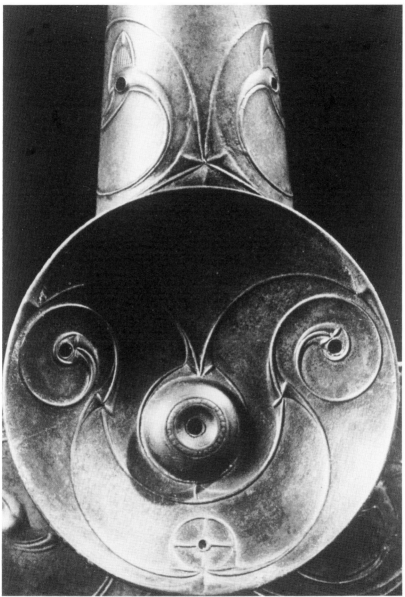

Plate 51. Unprovenanced, Ireland: The 'Petrie Crown' : detail of one horn and disc: diameter of disc 60 millimetres (2.4 inches). (National Museum of Ireland, Dublin. Photograph: Belzeaux-Zodiaque.)

the Petrie crown is visible on a first-century AD gold strip from Lambay Island, site of a cemetery probably of Brigantian refugees from the conquest of northern Britain. Such a wide variety of suggested dates does, however, show how long-lasting very late La Tène designs were in Ireland.

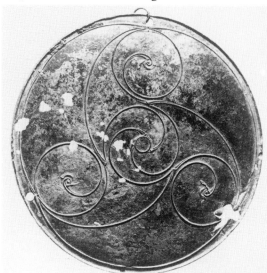

Plate 52. Loughan Island, River Bann, County Antrim, Northern Ireland: bronze disc with edge holes for suspension: diameter 105 millimetres (4.1 inches). (Ulster Museum, Belfast. Photograph: Ulster Museum.)

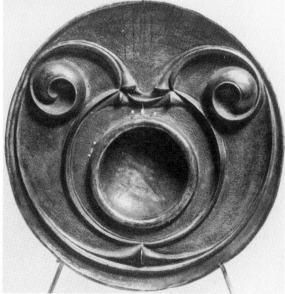

Plate 53. Unprovenanced, Ireland: bronze 'Monasterevin' type disc: diameter 272 millimetres (10.7 inches). (British Museum, London. Photograph: Belzeaux-Zodiaque.)

5
The Roman impact

Elsewhere in Britain the effect of Roman occupation was notable if varied. In the Roman civilian province in southern and eastern Britain very little Celtic art, certainly in metal, appears to have survived. What did shows Roman influence in the use of die-stamping rather than the more individual cast or repoussé work, and greater use of square-edged shapes (plates 54-5). Further north in Brigantia, stretching from southern Yorkshire and Lancashire into southern Scotland, the Roman garrisons of Hadrian's Wall appear to have provided a market for small items such as brooches, horse trappings and metal plaques to decorate such things as boxes. In addition the influence of southern refugees can be seen in the introduction of new techniques of highly decorated metalwork not previously seen in this area, though sometimes applied to Roman types of objects. An example is the Elmswell plaque (plate 55). This shows a compressed Celtic lyre-palmette design with pseudo birds' heads in the corners, the overall effect producing almost a last mocking Celtic face. The red and blue enamelled lyre scroll at the top may show Icenian and Belgic influence in the use of enamel, but the vine scroll itself is typically Augustan. Similarly the gilt-bronze Aesica brooch from a guard chamber at Great Chesters on Hadrian's Wall shows the application to a Roman type of fantailed brooch of Celtic lyre-palmettes with swan-like water birds on the 'fan' and the circular plate which the bow joins (plate 56). From Brigantia too came a considerable number of cheerful little 'dragonesque' brooches, formed in an S curve with crested heads and enamelled bodies. And to the west rather than the north, even the impressive gilt Carmarthen brooch (plate 57), already referred to, is of a type mostly found in the Roman period : attempts to place it earlier seem misguided and its echoes of the Snettisham style are very faint indeed; its decoration is much more like that of the Llandysul collar (plate 42).

Still further north, the Mortonhall scabbard (plate 58) and the Stichill collar (plate 59) show the continuing evolution of Celtic metalwork. Both are probably late first-century AD in date. The Mortonhall scabbard has the lower part of its design made up of trumpet curves surrounding S scrolls and of enclosing peltas : the upper part bears a saltire — a four-armed triskele perhaps (fig.

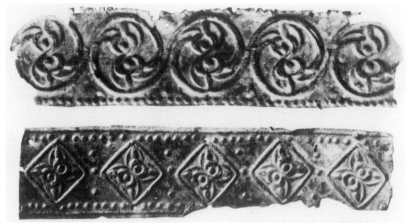

Plate 54. Rodborough Common, Gloucestershire: bronze die-stamped casket-ornament strips: widths 27 and 26 millimetres (1.0 and 1.1 inches). (British Museum, London. Photograph: courtesy of the Trustees of the British Museum.)

4). The Stichill collar is hinged at the back and fastened at the front with a pin, different in shape from the Llandysul collar or its Wraxall relative (plate 42). The sides and back are engraved : at the front are two plates riveted on and bearing a so-called swash-N design, a distant descendant of the classical acanthus scroll which in northern Britain was used to decorate rectangular spaces, which are themselves Roman rather than Celtic.

From north of the Forth-Clyde line comes a series of massive

Plate 55. Elmswell, Humberside: bronze casket mount on iron base with red and blue-green enamel: width 240 millimetres (9.4 inches). (Kingston-upon-Hull Transport and Archaeology Museum, Hull. Photograph: courtesy of the Trustees of the British Museum.)

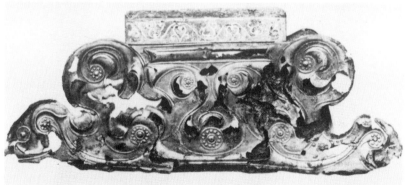

armlets and horse trappings, frequently enamelled (plate 60). The armlets are mostly pairs and show the sinuous trumpet curves typical of Brigantian metalwork (plates 58-9), the later Irish material (plates 50-3) and the Deskford carnyx (plate 36). The

Plate 56. Great Chesters, Northumberland: gilt bronze brooch: length 103 millimetres (4.1 inches). Museum of Antiquities, University of Newcastle upon Tyne. Photograph: Museum of Antiquities, University of Newcastle upon Tyne.)
Plate 57. Carmarthen, Dyfed: parcel-gilt silver brooch: length 62 millimetres (2.4 inches). (Carmarthen Museum. Photograph: National Museum of Wales, Cardiff.)

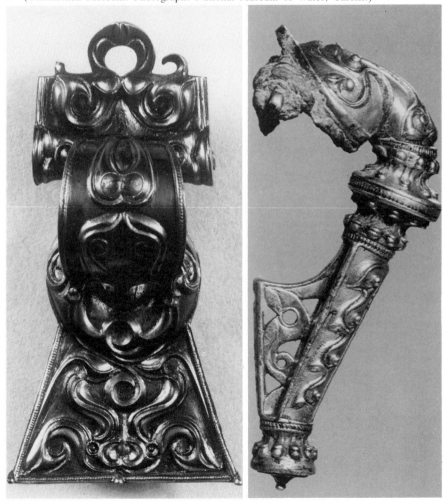

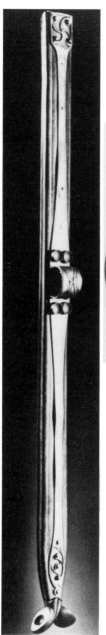

Plate 58. Mortonhall, Edinburgh: bronze sword scabbard: width 55 millimetres (2.2 inches). (Royal Museum of Scotland, Edinburgh. Photograph: Univers des Formes.)

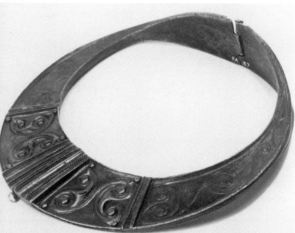

Plate 59. Stichill, Tayside: bronze neck collar with pin fastening: diameter (outer) 190 millimetres (7.5 inches). (Royal Museum of Scotland, Edinburgh. Photograph: Royal Museum of Scotland.)

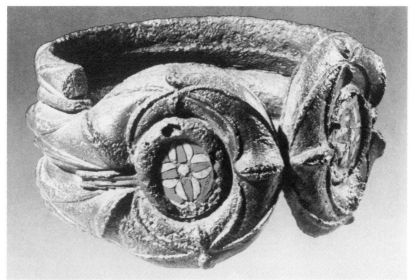

Plate 60. Drummond Castle, Pitkelloney, Tayside: bronze massive armlet with red and yellow enamel inlay, one of a pair: diameter 144 millimetres (5.7 inches). (British Museum, London. Photograph: Univers des Formes.)

enamel is complex, employing more than one colour, and looks forward to the post-Roman Celtic metalwork and manuscript art.

That Celtic art did not die out in the Roman period is proved by provincial art itself; it may have had to change shape and function under the conquerors but, when they left, it exploded into vigorous new life in both Ireland and Britain. In early Christian times it absorbed new elements from the invading Germanic tribes and from Mediterranean sources to produce, yet again, a new composite style which still firmly bears the stamp of its Celtic ancestry.

6
Museums to visit

The largest collection of insular Celtic art is to be found in the British Museum, which includes important continental examples as well. Other major museums contain important material from their particular Celtic provinces. Many local museums also contain iron age material, sometimes including pieces of artistic as well as archaeological importance. Intending visitors are advised to find out the times of opening before making a special journey.

Ashmolean Museum of Art and Archaeology, Beaumont Street, Oxford OX1 2PH. Telephone: Oxford (0865) 512651.

British Museum, Great Russell Street, London WC1B 3DG. Telephone: 01-636 1555 or 1558.

Cambridge University Museum of Archaeology and Anthropology, Downing Street, Cambridge CB2 3DZ. Telephone: Cambridge (0223) 359714.

Hull Transport and Archaeology Museum, 36 High Street, Kingston upon Hull. Telephone: Hull (0482) 222737.

Merseyside County Museums, William Brown Street, Liverpool L3 8EN. Telephone: 051-207 0001 or 5451.

National Museum of Ireland, Kildare Street, Dublin 2. Telephone: Dublin (01) 765521.

National Museum of Wales, Cathays Park, Cardiff CF1 3NP. Telephone: Cardiff (0222) 397951.

Norwich Castle Museum, Norwich, Norfolk NR1 3JU. Telephone: Norwich (0603) 611277.

Royal Museum of Scotland (formerly the National Museum of Antiquities of Scotland), Queen Street, Edinburgh EH2 1JD. Telephone: 031-557 3550.

Ulster Museum, Botanic Gardens, Belfast BT9 5AB. Telephone: Belfast (0232) 668251.

7
Further reading

The Celts : general

Collis, John. *The European Iron Age*. Batsford, 1984. (An interesting view of the Celts and their neighbours.)

Filip, Jan. *Celtic Civilization and its Heritage*. Academia, Prague, and Collets, Wellingborough, second edition 1976.

Kruta, V. and Forman, W. *The Celts of the West*. Orbis, 1985.

Powell, T. G. E. *The Celts*. Thames and Hudson, second edition 1980. (Virtually unchanged since 1958 but still a basic text).

Ritchie, W. F. and J. N. G. *Celtic Warriors*. Shire Publications, 1985.

Celtic art : general

Duval, Paul-Marie. *Les Celtes*. Gallimard, 1977. (Proposes a new stylistic scheme. Sumptuous illustrations.)

Jacobsthal, Paul. *Early Celtic Art* (two volumes). Clarendon Press, reprint 1969 (1944). (The starting point for all later studies of Celtic art, but does not deal with the British Isles.)

Megaw, J. V. S. *Art of the European Iron Age*. Adams and Dart, 1970. (An overview and catalogue which includes the British Isles.)

Sandars, Nancy K. *Prehistoric Art in Europe*. Penguin, second edition 1985. (Chapters 7-9 for the Celts.)

The British Isles in the iron age

Cunliffe, B. W. *Iron Age Communities in Britain*. Routledge and Kegan Paul, second edition, 1978.

Harding, D. W. *The Iron Age in Lowland Britain*. Routledge and Kegan Paul, 1974.

Megaw, J. V. S., and Simpson, D. D. S. (editors). *British Prehistory*. Leicester University Press, 1979. (Chapter 7.)

Raftery, B. *La Tène in Ireland: Problems of origin and Chronology*. Marburg, 1984. (Thorough coverage of Ireland. Good illustrations.)

Ross, Anne. *Pagan Celtic Britain*. Routledge and Kegan Paul, 1967. (Iron age and Romano-British beliefs and iconography.)

Savory, H. N. *Guide Catalogue to the Early Iron Age Collections*. National Museum of Wales, 1976. (Covers Wales.)

Celtic art in Britain and Ireland

Brailsford, John. *Early Celtic Masterpieces in the British Museum.* British Museum Publications, 1975. (Excellent photographs and drawings.)

Fox, Cyril. *Pattern and Purpose : A survey of Early Celtic Art in Britain.* National Museum of Wales, 1958. (The pioneer study.)

Kilbride-Jones, H. E. *Celtic Craftsmanship in Bronze.* Croom Helm, 1980. (Highly idiosyncratic but splendid drawings.)

MacGregor, Morna. *Early Celtic Art in North Britain* (two volumes). Leicester University Press, 1976. (Covers the area northwards from southern Yorkshire and Lancashire.)

Stead, I. M. *Celtic Art in Britain before the Roman Conquest.* British Museum Publications, 1985. (A thorough and scholarly introduction, with many colour illustrations.)

Stead, I. M. *The Battersea Shield.* British Museum Publications, 1985. (A detailed study of a masterpiece of Celtic art.)

Acknowledgements

The number of workers active in the field of early Celtic art remains constantly small; for this if no other reason one is continually relying on the patience of the same group of friends and colleagues. We must mention here : Professor Otto-Herman Frey, Emeritus Professor Martyn Jope, Dr Morna MacGregor, Dr Barry Raftery, Dr H. N. Savory, Dr Mansel Spratling, Dr Ian Stead, Dr R. B. K. Stevenson and Richard Warner. We must record with gratitude the financial support of the Australian Research Grants Scheme. The institutions and individuals who have assisted in building up the visual archive necessary for any serious study of art are acknowledged in the captions to our illustrations. Finally, Emeritus Professor Stuart Piggott started it all in Edinburgh some thirty years ago so it seems only right and proper to dedicate this picture essay as a birthday present for his un-godchild.

Hyde Park, South Australia *2 August 1985*

Index

Page numbers in italics refer to illustrations